Decorated Country Stoneware

By Don and Carol Raycraft

Photographs by:
Jean Ann Honegger
Mike Caraker
Bob and Judy Farling
Carol Raycraft

COLLECTOR BOOKS
P.O. Box 3009
Paducah, KY 42001

The current values in this book should be used only as a guide. They are not intended to set prices, which vary from one section of the country to another. Auction prices as well as dealer prices vary greatly and are affected by condition as well as demand. Neither the Author nor the Publisher assumes responsibility for any losses that might be incurred as a result of consulting this guide.

The authors appreciate the assistance of the following:

Mr. and Mrs. Gordon Honegger
Mr. and Mrs. Bob Farling
Mike and Barb Caraker
Elmer and Merrilyn Fedder
Mr. and Mrs. Ron Steidinger
Muleskinner Antiques
Captain Alex Hood
Marvin Voelker
Loren and Judy Thomson
Bill Schroeder
Tom and Mary Ott
Ray and LaVerne Jaudes

Additional copies of this book may be ordered from:

COLLECTOR BOOKS
P.O. Box 3009
Paducah, Kentucky 42001

@ $5.95 Add $1.00 for postage and handling.

Copyright: Don and Carol Raycraft, 1982
ISBN: 0-89145-181-1

Printed by IMAGE GRAPHICS, Paducah, Kentucky

Introduction

In recent years the price levels for stoneware have tended to become relatively standard across the country. A collector in California can expect to pay $250.00-275.00 for the same "bird" jug that a buyer in New Hampshire might find for $175.00-200.00. It is difficult to find a great piece of decorated stoneware at a bargain price because almost every home-oriented magazine has been promoting the "country look" on its pages, and jugs and crocks are featured in almost every issue.

In the summer of 1980 we were traveling across New York state on Route 20 and went past a yard sale. One of us noticed several pieces of stoneware on a card table and we quickly braked to a halt. (Route 20 runs across one of the nation's premier areas for the manufacture of stoneware. In the nineteenth century there were many major potteries in northcentral and northeastern New York. Pottery with marks from Lyons, Fort Edward, Troy, Utica, and Rochester are eagerly sought by collectors.) We were able to purchase a three gallon crock with a blue cobalt floral spray for $25.00. The other three pieces on the table were also from New York makers but contained major chips or cracks that limited their value. Perhaps a best source for decorated stoneware would be in and around the area in which it was originally produced. The crock we found was made in Rochester about 1870.

The stoneware pottery produced in New York and at Bennington, Vermont was totally utilitarian. It was used for a wide variety of every day chores. There is no question that pieces remain in basements filled with eighty year old pickles, plums, or peaches.

The great pieces with elaborate decorations were produced in limited quantity and often only on special order. Few of these pieces survive. Jugs and crocks with relatively simple designs, similar to the one we purchased on Route 20, are still making their way to the market place through a variety of methods. The trick is to find the jug or crock before it passes through too many hands and the price becomes prohibitive.

Evaluating Stoneware

The condition of a piece of stoneware is critical in determining its value. Major cracks, chips, or repairs significantly effect the price a piece can demand. Seldom does a piece of stoneware find its way to the marketplace without a flaw.

In the production of stoneware there were many opportunities for damage. In the firing process, pebble bursts, stacking problems in the kiln, and difficulties with the cobalt slip breaking down were problems commonly faced by potters. Pieces that were severly flawed were sold as "seconds" or "thirds" for reduced prices at the pottery. The majority of the pieces that

47119

have survived intact contain minor kiln related flaws that typically have little influence on the price.

Nineteenth century stoneware was primarily utilitarian in nature. Each piece was specifically designed to serve a function. When a piece was broken or severly cracked it was thrown away. It was commonly available, inexpensive, and functional.

Potters produced a wide variety of household and kitchen related pieces. A partial list from Bennington in the late 1850's included: jugs (8 sizes), open cream pots (8 sizes), churns (5 sizes), preserve jars (7 sizes), covered cake pots (4 sizes), pitchers (5 sizes), flower pots (7 sizes), water kegs, mugs, beer botties, and chamber pots.

Collecting Country Stoneware

In the mid to late 1960's we repeatedly debated purchasing "bird" jugs and crocks for $50.00-65.00. There was a seemingly limitless supply of cobalt decorated stoneware but only a limited amount of dollars to trade. We purchased an unmarked two gallon jug with a hastily brushed bird for $24.00 through the mail from a New York state dealer in 1968. The jug ended up one summer's day under a tree and was run over by the too sharp turn of a tractor-mower. Today the jug with the appropriately patched handle would sell for three to four times the original price when it was free from any handicaps.

Elaborately decorated jugs or crocks with incised birds or scenes are almost nonexistent and command prices in four figures. Brush painted pieces with human figures, animals, ships, flags, fish, or houses are almost as rare and are equally expensive. The most commonly found cobalt decorated pieces contain leaves, flowers, or hastily drawn swirls or numerals.

These five processes used to decorate stoneware are significant in determining their relative value and in gaining insight into the period of time in which the pottery was produced.

1. **Incising**

 Stoneware was incised from the late eighteenth century until about 1830. The process involved scratching a design into the clay with a pointed rod or stick. The process was difficult and took a great deal of time. As the number of potteries grew and the competition increased among them, a less time consuming method of decorating stoneware had to be found.

2. **Brush Painting**

 From the early 1830's until after 1900, some stoneware was decorated to some extent by a stiff brush and cobalt slip. Brush painting peaked in the early 1870's and gradually gave way to decoration applied by stencils.

 The era of brush painting was eventually doomed by the constant

necessity to cut prices and increase productivity. Elaborately executed birds, animals, and scenes were time consuming and involved siginificant labor costs. After 1875 there were few potteries that allowed their decorators the freedom to let their imaginations and brushes wander at will. The decorators themselves changed their approach to brush painting when the pottery owners began to pay them by the piece rather than by the day.

The stoneware produced between 1880 and 1900 tended to be simply decorated with quickly brushed swirls or numbers that indicated the jug's contents in gallons.

Many eastern potteries produced jugs for distilleries and storekeepers with their names and addresses boldly brushed in cobalt script. This type of decoration is found on both hand thrown and molded jugs that date after 1880.

3. **Slip-cupping or Trailing**

Slip-cupping refers to the process of decorating stoneware with a tool similar to a cake decorator. The slip came out of the clay slip cup in a fashion much like tooth paste comes out of a tube. The trail of slip coming from the cup left a raised decoration on the surface of the stoneware. Slip was made by carefully combining white clay and water into a thick creamy mixture. Ground cobalt was used to color the slip. Slip-cupping was especially popular in the late 1840's and early 1850's. The process became too costly and eventually was replaced by stenciled decoration or quickly brushed cobalt swirls.

4. **Stenciling**

In the late nineteenth and early twentieth centuries (c. 1880-1920) a great deal of stoneware was stenciled with the name of the pottery and a simple decoration. The stencil was placed against the stoneware and a brush dipped in cobalt was pushed across it. Much of the stenciled pottery came out of western Pennsylvania and West Virginia. Hamilton and Jones of Greensboro, Pennsylvania and A.P. Donaghho of Parkersburg, West Virginia were especially productive.

5. **Impressing or Stamping**

The potter's mark was often pressed into the wet clay of a jug or crock to indicate the name and location of its maker. The stamp was made from printer's type, fired clay or carved wood. In the nineteenth century simple designs of birds or flowers were also stamped or impressed in the neck of jugs. The capacity mark that indicated the number of gallons the piece would hold also was stamped or impressed into the stoneware. In the early 1800's simple lines or small designs were also stamped or impressed into stoneware. Often a tool called a "coggle wheel" was used. The stamping in the early nineteenth century was usually done on pottery with an ovoid or pear shape. An ovoid jug is considerably smaller at the base than at the shoulder. As the nineteenth century wore on stoneware jugs gradually became almost cylindrical in form.

Stoneware Chronology

1630's Charlestown, Massachusetts earthenware pottery established.

1730 Crolius Pottery in New York City in operation.

1740 Early attempt at stoneware production in Charlestown, Massachusetts.

1790's Dying days of earthenware because of lead glazes. Beginning of switch to stoneware production. Earthenware continued to be made in some areas (especially Pennsylvania) until the 1840's.

1793 John Norton opens Bennington Pottery in Bennington, Vermont.

1825 Erie Canal opens.

1830's Establishment of large stoneware factories and increased production on a large scale.

1860's Refrigeration at home becomes more common.

1861-1881 E. and L.P. Norton/Bennington, Vermont: mark on stoneware. Period at Bennington when more stoneware produced than at any other time.

1876 Centennial Exposition opened up era of art pottery with an emphasis on Oriental and Greek forms.

1894 Descendents of John Norton finally out of Bennington Pottery.

1919 Prohibition kills beer bottle and whiskey jug business.

1920 Just about the end of stoneware produced on a large scale in the United States.

Decorated Stoneware

New York Stoneware Co., Fort Edward, New York. Slip trailed cobalt dragon fly, marked with an impressed "6", probably to indicate a number in a set or series rather than the size of contents in gallons. c. late 1870's. $210.00-235.00

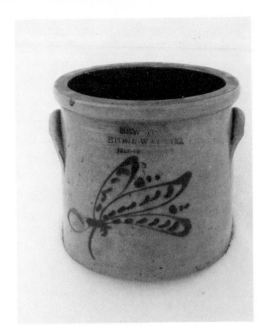

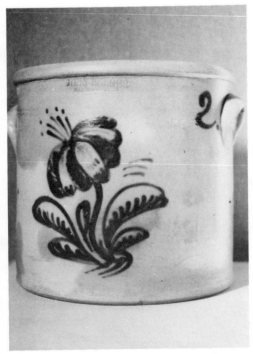

Two gallon crock, John Burger, Rochester, N.Y., c. late 1860's. Slip trailed and brush painted flower. $185.00-215.00

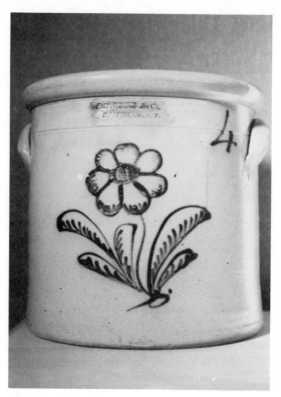

Four gallon crock, Burger and Co., Rochester, N.Y., c. early 1870's. $185.00-215.00. A close inspection of the two Burger crocks indicates that it is highly probable that the same decorator did both pieces several years apart.

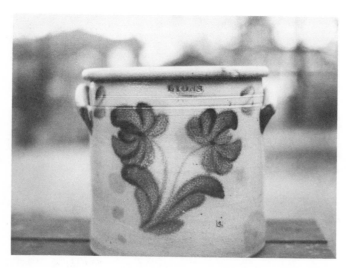

Two gallon crock, double cobalt flowers. Lyons, N.Y., c. late 1850's-early 1860's. $165.00-185.00

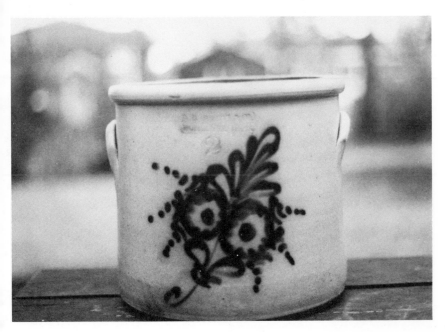

Two gallon crock, F.B. Norton, Worcester, Mass., c. 1870's. $150.00-175.00

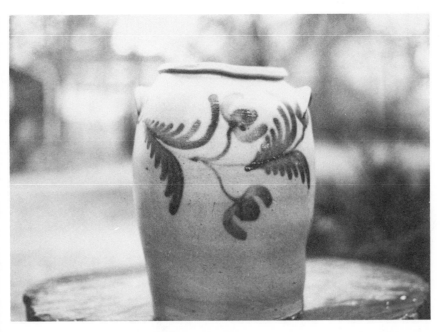

Stoneware jar, no potter's mark, probably N.Y. State. Brush painted flowers, leaves, and vine, c. 1850's. $150.00-175.00

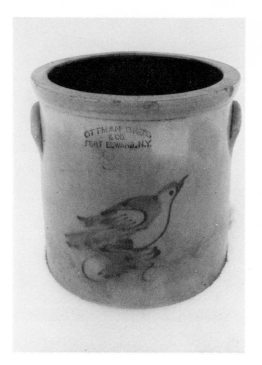

Three gallon crock, brush painted bird, Ottman Brothers and Co., Fort Edward, New York, c. 1870's. $240.00-275.00. This is an excellent example of a well executed robin(?) painted with a brush. Most cobalt birds brushed or slip trailed on stoneware are difficult to identify by type.

Two gallon crock, brush painted bird. New York Stoneware Co., Fort Edward, New York, c. mid to late 1870's. $240.00-275.00

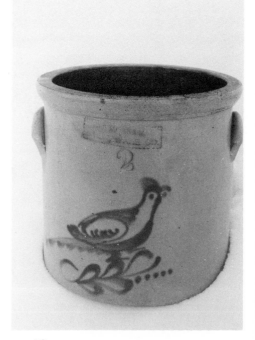

10

Four gallon crock, brush painted "chicken pecking corn," Fort Edward, N.Y. $350.00-450.00. The "chicken pecking corn" design is almost always found on crocks rather than stoneware jars or jugs. Examples of chickens pecking have also been located on butter churns on rare occasions. It is interesting to note that the chicken is almost always pecking to the left rather than to the right.

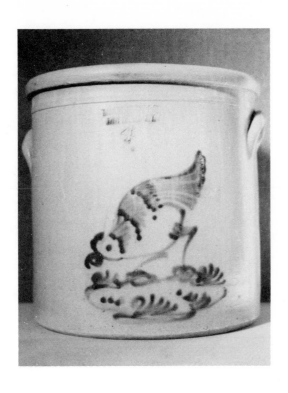

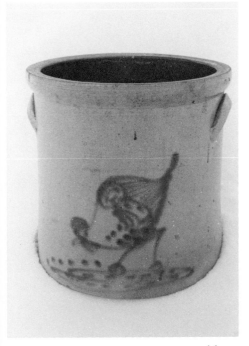

Four gallon crock, brush painted "chicken pecking corn". No potter's mark, probably made in N.Y. State, c. 1870's. $350.00-395.00

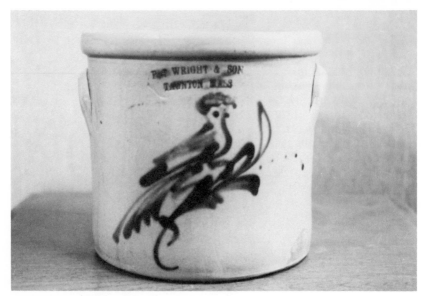

One gallon crock, brush painted bird, F.T. Wright and Son, Taunton, Mass. early 1870's. $225.00-240.00. Potteries changed hands very frequently. The best guide to use in accurately dating a given mark is to use the city directory exactly when the pottery was in operation. Alexander Wright (F.T. Wright's father?) was also in the pottery business in Taunton from about 1846 to 1855.

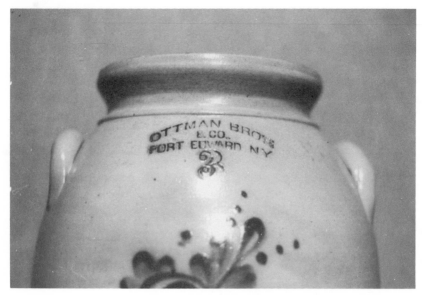

Ottman Bros. and Co., c. 1870-1890 mark, Fort Edward, N.Y.

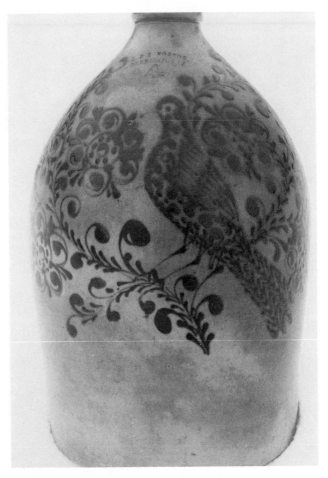

Four gallon jug, J. and E. Norton, Bennington, Vermont, 1850-1861 mark, slip trailed cobalt decoration of peacock and flowering vine. $2,500.00-3,500.00. This spectacular piece of decorated stoneware is from the collection of Mr. and Mrs. Michael Caraker. Approximately 80 per cent of the surface of the jug is covered with elaborate cobalt decoration. Examples of this quality were produced at Bennington and other eastern potteries only on special order or by the individual decorators to display their skills. Pieces of this quality that have survived without major cracks or chips are almost nonexistant.

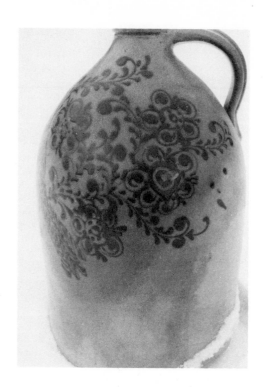

Another view of the J. and E. Norton 4 gallon jug.

One gallon jug. Haxstun and Co., Fort Edward, N.Y. Brush painted "robin". c. 1875. $185.00-210.00

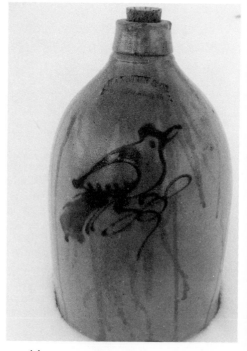

14

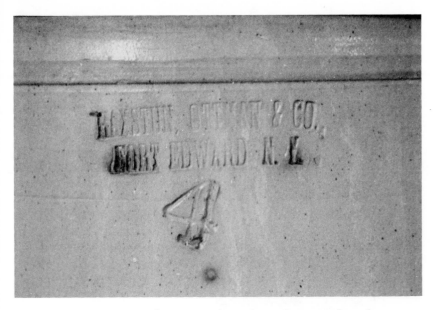

Haxstun, Ottman and Co., c. 1867-1872 mark, Fort Edward, N.Y.

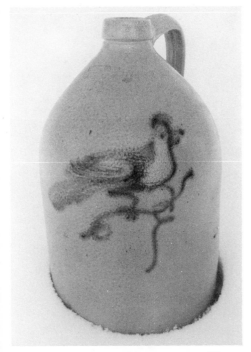

Two gallon jug, Haxstun, Ottman and Co., Fort Edward, N.Y., c. 1870. $135.00-145.00

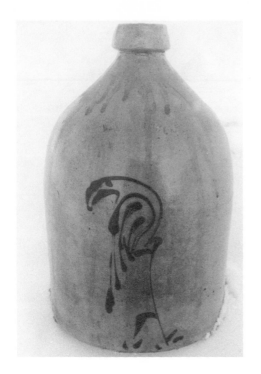

One gallon jug, Whites, Utica. Brush painted flamingo, c. 1875. $200.00-215.00

Two gallon jug, Whites, Utica. N.Y., c. 1875. $165.00-175.00

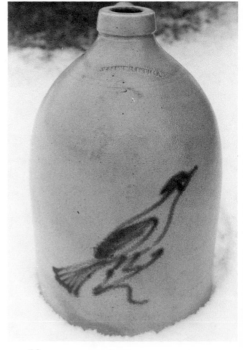

Two gallon jug, no potter's mark, c. late 1870's. $135.00-150.00

Two gallon jug, Whites, Utica, New York, slip trailed, c. 1875. $185.00-210.00

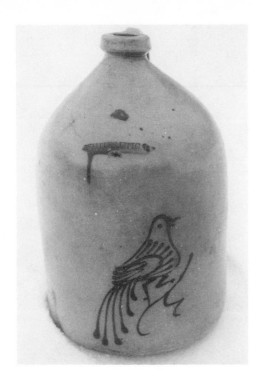

Three gallon jug. Whites, Utica, N.Y. slip trailed, c. 1875. $185.00-210.00

Five gallon jug, double stamped with the name of the vendor. Produced for "M J Gately
65 Kneeley
Boston".
$225.00-250.00

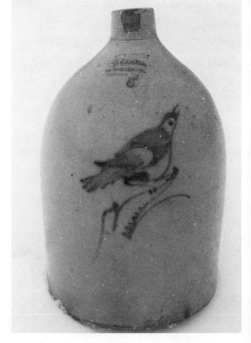

18

S. Risley, Norwich, Conn. Ovoid jug, brush painted flower, early 1840's. $200.00-225.00

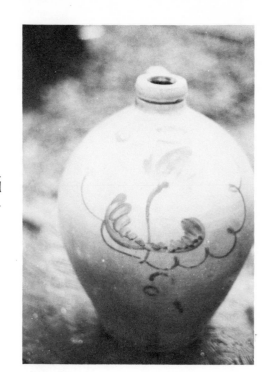

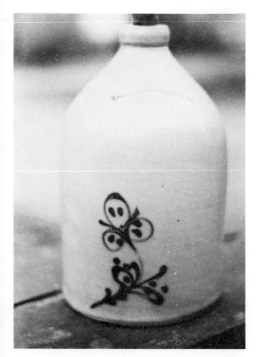

Slip trailed flower, W. Roberts, Binghamton, N.Y. c. 1870's. $120.00-130.00

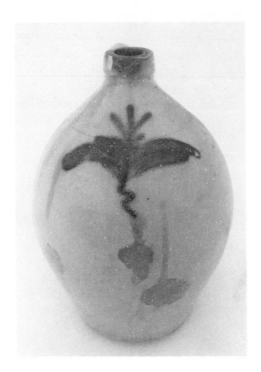

One gallon ovoid jug, brush cobalt decoration. No potter's mark, c. 1840. $160.00-175.00

Three gallon ovoid jug, I. Seymour and Co., Troy, N.Y., c. 1824. $200.00-225.00

One gallon ovoid jug, no maker's mark, cobalt brush decoration, c. 1840. $120.00-130.00

One gallon ovoid jug, no maker's mark, brush cobalt decoration, c. 1840. $100.00-115.00

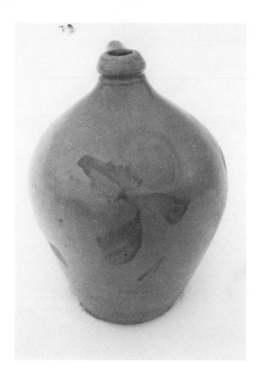

One gallon ovoid jug, no maker's mark, brush cobalt decoration, c. 1830. $100.00-115.00

Three gallon ovoid jug, F.W. Merrill, c. 1840's. Brush cobalt over maker's mark. $115.00-125.00

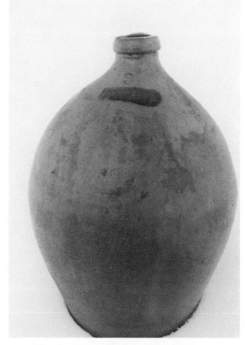

One gallon jug. N.A. White and Son, Utica, N.Y. Slip trailed "pine tree" or "Christmas tree" decoration. c. 1880's. $115.00-125.00

Four gallon crock, no maker's mark, probably midwestern in origin. Slip trailed reverse "pine tree". c. 1880's. $85.00-115.00

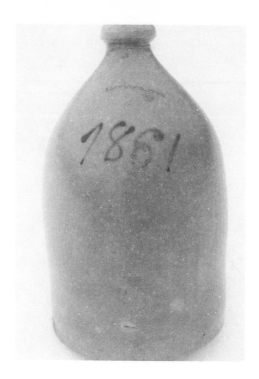

Two gallon jug, I. Seymour, Troy, N.Y., dated 1861. $150.00-165.00

Two gallon jug, M. Woodruff, Cortland, N.Y. Brush painted flower, c. late 1870's. $175.00-185.00

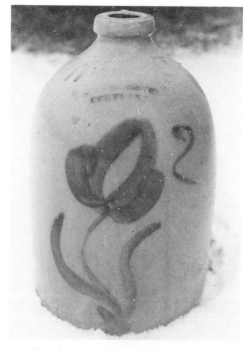

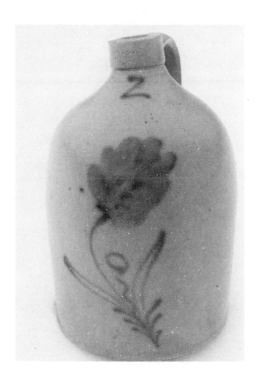

Two gallon jug, no maker's mark. Brush painted flower. c. 1870's. $175.00-185.00

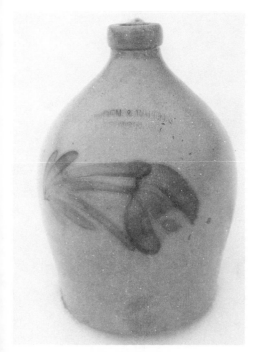

Two gallon jug, Cowden and Wilcox, Harrisburg, Pa. Brush painted decoration, c. 1870's. $115.00-125.00

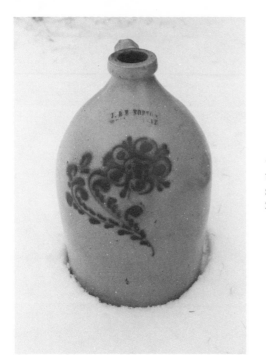

One gallon jug, J. and E. Norton. Slip trailed cobalt floral spray. 1850-1859 mark. $175.00-185.00

Three gallon jug, slip trail cobalt leaf. No maker's mark, c. 1880. $115.00-130.00

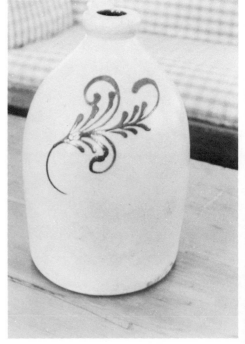

One gallon jug, New York Stoneware Co., Fort Edward, N.Y. Brush painted flower, c. 1870's. $120.00-140.00

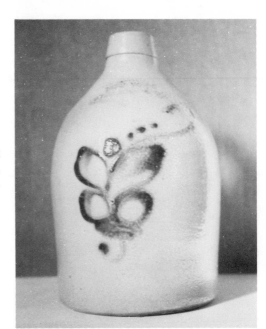

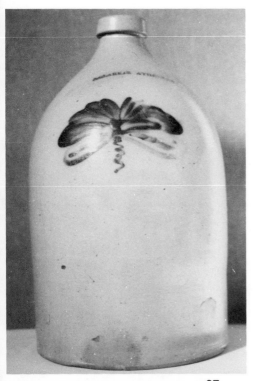

Three gallon jug, N. Clark Jr., Athens, N.Y. Brush painted "butterfly", c. late 1870's. $160.00-175.00

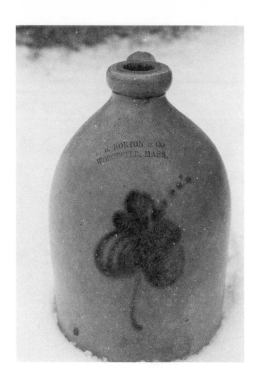

One gallon jug, F.B. Norton and Company, Worcester, Mass. Slip trailed and brush painted flower, c. 1870's. $130.00-145.00

Two gallon jug, C. Hart and Co., Ogdensburgh, N.Y. Slip trail decoration, c. 1850's. $200.00-225.00

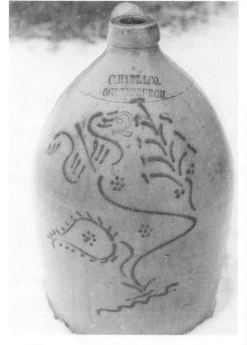

Three gallon vendor's jug. "Cushman and Co. 376-378 Broadway, Albany, N.Y." c. 1880. $95.00-115.00

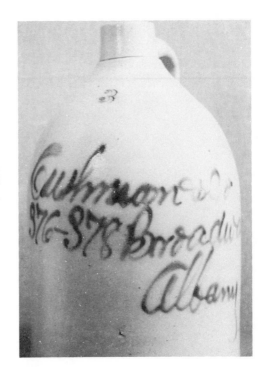

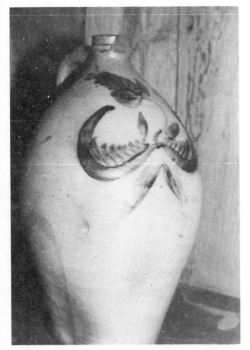

Unmarked two gallon ovoid jug, brush painted flower, c. early 1840's. Touches of cobalt decoration on applied strap handle. $130.00-150.00

One half gallon jug, redware, probably from Pennsylvania, c. late 1840's. $85.00-110.00

Two gallon jug, unmarked, brush painted flowers, c. late 1870's. $150.00-175.00

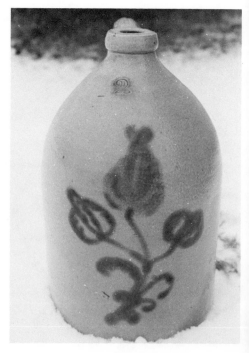

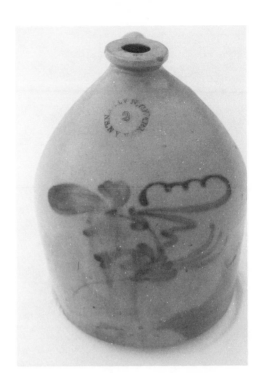

Two gallon jug, N. Clark Jr., Athens, N.Y., c. late 1870's. $115.00-130.00

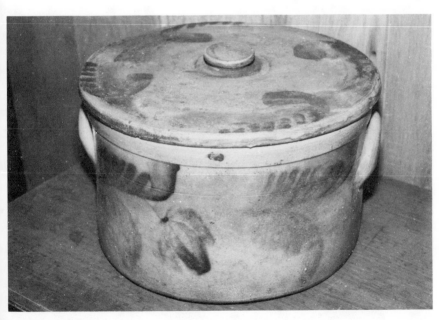

Butter crock, no maker's mark. Brush decoration, 13" diameter, c. 1850's. $240.00-280.00

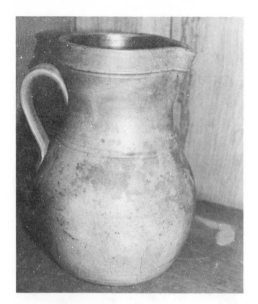

White's, Utica, N.Y. Pitcher, impressed mark, no decoration, early 1870's. $115.00-120.00

Impressed "White's" mark.

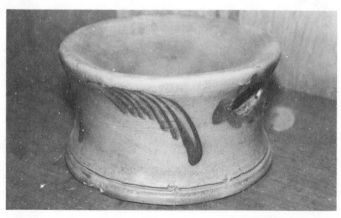

Spittoon, cobalt brushed decoration, no maker's mark, c. 1860's-1870's. $200.00-225.00

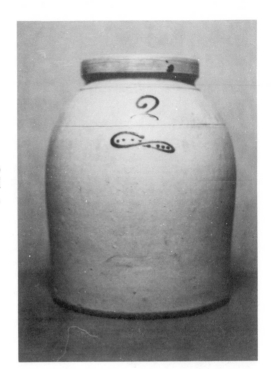

Stoneware preserve jar, no maker's mark. Slip trailed cobalt "snake" decoration, c. 1870's. $50.00-60.00

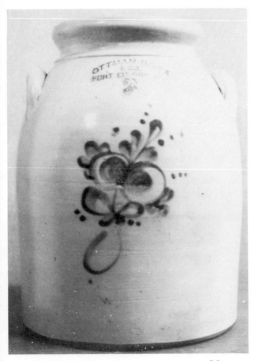

Stoneware two gallon jar, Ottman Brothers, Fort Edward, N.Y. Cobalt floral spray, c. mid-1870's. $150.00-175.00

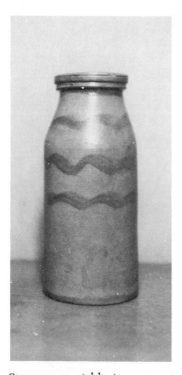

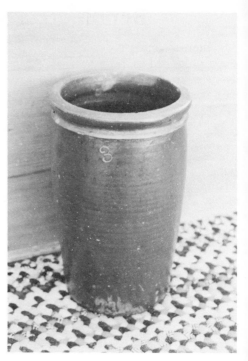

Stoneware pickle jar, no potter's mark. Probably western Pennsylvania, c. 1860-1875. $95.00-110.00

Impressed "3" on preserve jar. Albany slip, no potter's mark, probably White Hall, Illinois area, c. 1860's. $65.00-75.00

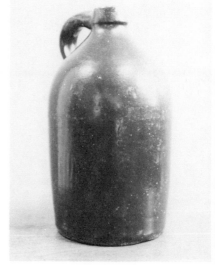

One gallon, Albany slip, no potter's mark, c. 1880's. $50.00-60.00

Bennington Stoneware

The most intensely collected examples of American country stoneware were produced in Bennington, Vermont from 1793 until 1894. There are thought to be twelve primary pottery marks found on Bennington stoneware. The marks range from the Bennington Factory (pre-1823) to the Edw'd Norton Co. mark (1886-1894).

The E. and L.P. Norton mark (1861-1881) was in use for the longest period. This may be contrasted with the J. Norton and Co. (1859-1861) mark and the Norton and Fenton (1844-1847) mark that were in use for relatively brief periods.

E. and L.P. Norton pitcher-jug, 1861-1881 mark. $150.00-175.00

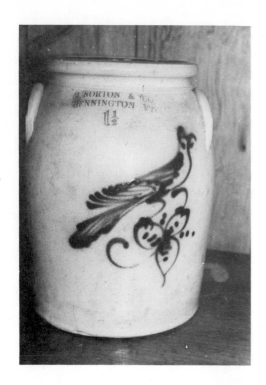

J. Norton and Co., 1½ gallon jar, "blue bird," 1859-1861 mark. $225.00-250.00

J. and E. Norton, one gallon jug, "bird on a stump," 1850-1859 mark. $250.00-275.00

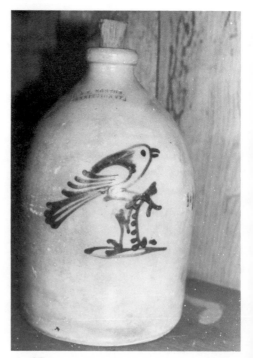

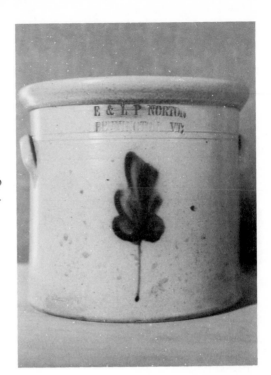

E. and L.P. Norton crock, deep cobalt floral design. $115.00-130.00

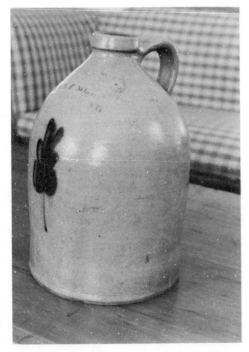

E. and L.P. Norton jug, deep cobalt floral design. $115.00-130.00

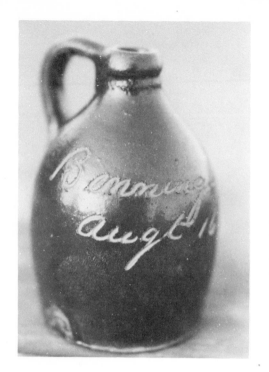

Miniature "Little Brown Jug," incised "Bennington Augt 16, 1877". Produced for the centennial celebration of the Battle of Bennington in the American Revolutionary War. The miniature jug covered with Albany slip is almost 3" high and 2" in diameter. it holds approximately two ounces of liquid.
$150.00-175.00

Four gallon jug. E. and L.P. Norton mark, cobalt floral spray. $200.00-225.00

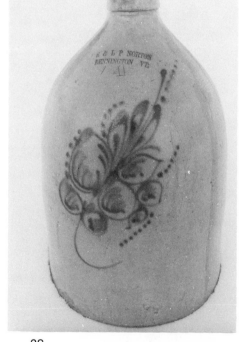

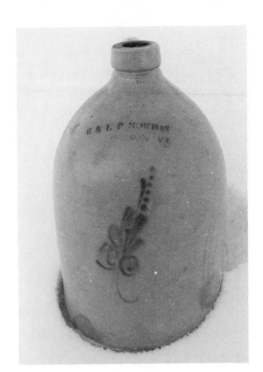

One gallon jug, E. and L.P. Norton mark, simple cobalt flower. $140.00-160.00

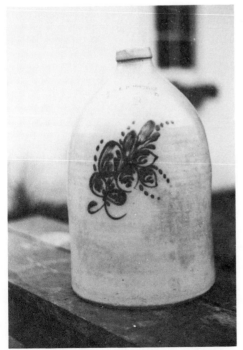

Three gallon jug, E. and L.P. Norton, 1861-1881. $160.00-175.00

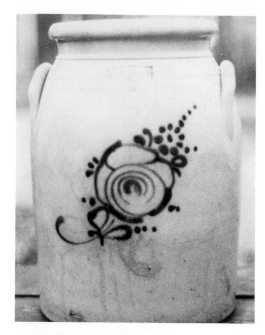

Three gallon jar, J. and E. Norton, 1850-1859. $140.00-175.00

The following eleven pieces of stoneware are **reproductions** with classic Bennington cobalt decorations.

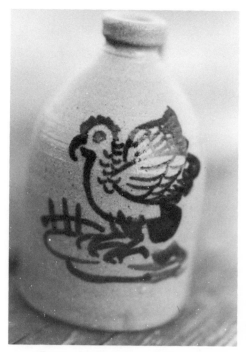

"The Cock," usually found with J. and E. Norton 1850-1859 mark.

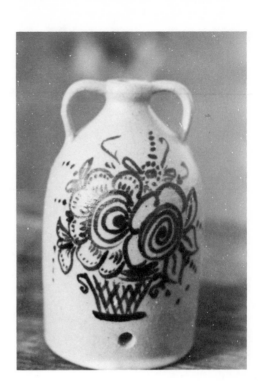

"Basket of Flowers," usually found with J. and E. Norton mark.

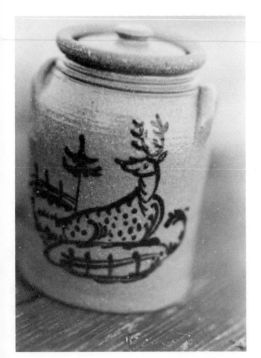

"The Deer," usually found with J. and E. Norton mark.

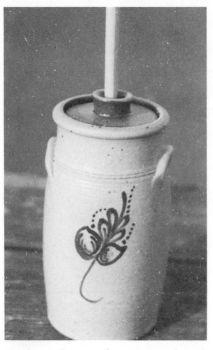
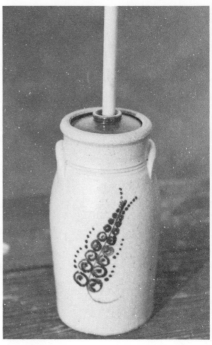

Dasher churn, decoration found with E. and L.P. Norton mark.

Simple flower design, often found on E. and L.P. Norton stoneware.

E. and L.P. Norton flower spray.

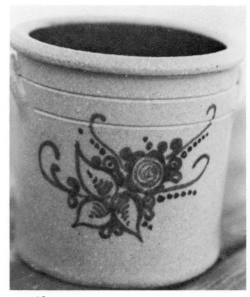

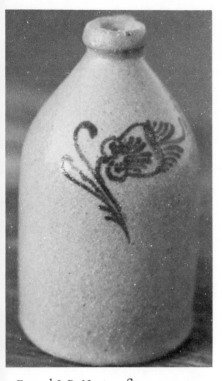 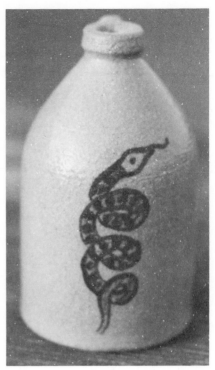

E. and L.P. Norton flower spray. "Snake."

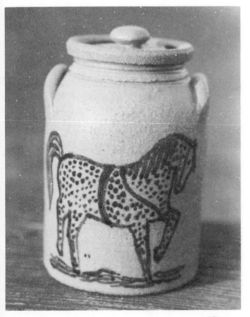

"Horse" stoneware jar.

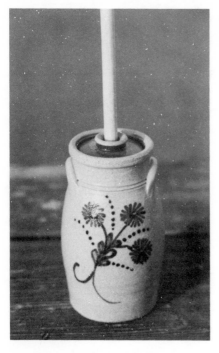 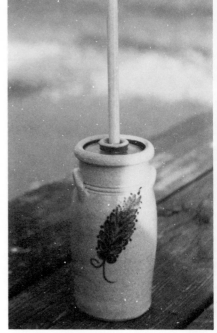

Stoneware churn. Stoneware churn.

Sleepy Eye

In 1883 a flour mill was established in Sleepy Eye, Minnesota. The Sleepy Eye Milling Company in an effort to stimulate sales began to put premiums in their Sleepy Eye Flour. The Minnesota Stoneware Company was contracted to produce a variety of premiums for the flour operation. Minnesota Stoneware was located in Red Wing, Minnesota from 1883 until 1906.

For a brief period the premiums were produced for Sleepy Eye at the Weir Pottery in Monmouth, Illinois. In 1906 Weir merged with six other potteries to form the Western Stoneware Company.

The flour plant remained in Sleepy Eye until 1921 when it was absorbed by the Kansas Flour Mills Company. The "Sleepy Eye" pitchers in five sizes were produced by the Western Stoneware Company for the Kansas based flour firm after 1921. The Monmouth, Illinois pottery produced a variety of premiums with the distinctive Indian head between 1921 and 1937.

In addition to stoneware premiums, collectors search diligently for advertising cards, cook books, spoons, rulers, and post cards.

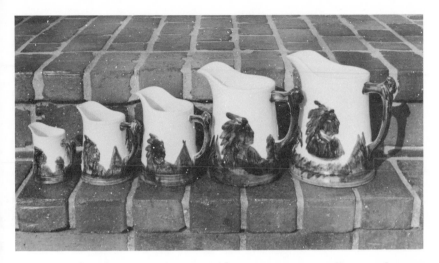

Five sizes of pitchers, ranging in size from ½ pint to a gallon. Perfect set, $1,000.00-$3,500.00

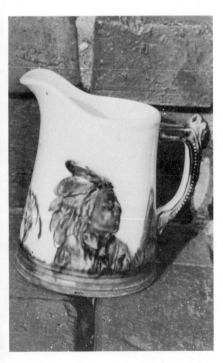

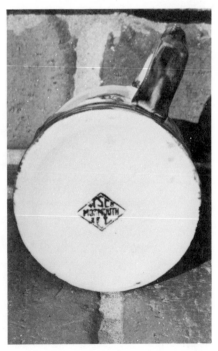

#3 pitcher, quart size, perhaps the most difficult of the five sizes to find. $225.00-275.00

Western Stoneware Co. Monmouth, Ill. mark on #3 pitcher.

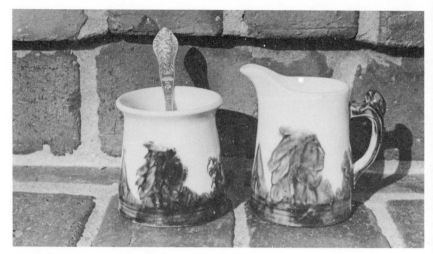

Sugar bowl and ½ pint pitcher or creamer, silver plate advertising spoon.
Sugar, $450.00; pitcher, $125.00-175.00; spoon, $125.00-150.00

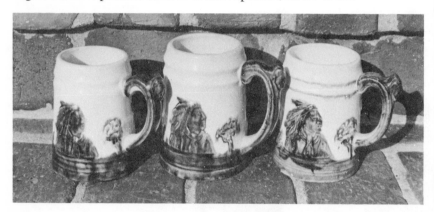

Two sizes of mugs. $175.00-200.00 each.

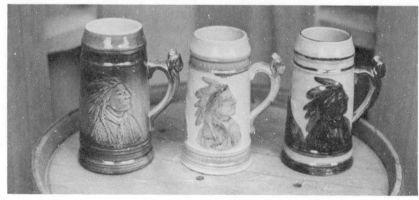

Three sizes of steins. $1,500.00, $700.00, $800.00

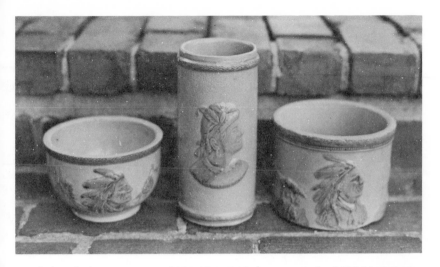

Salt bowl. $375.00; vase, $200.00-275.00; butter crock, $450.00-475.00

Reverse side of the butter crock.

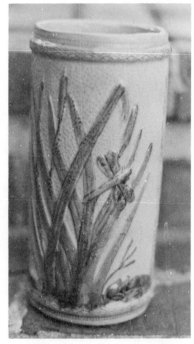

Reverse side of the vase.

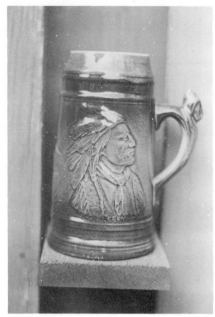

Very rare green stein. $1,500.00

Stoneware stein. $700.00

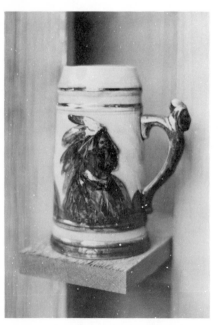

Brown and yellow stein. $800.00

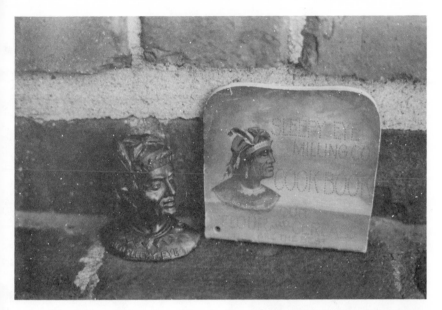

Bronze paper weight and cookbook shaped like a loaf of bread-"Sleepy Eye Milling Co. Cook Book." Paper weight, $700.00-800.00; cookbook, $200.00-250.00

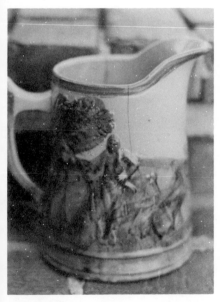

"Standing Indian" pitcher. $1,600.00-2,000.00

Flemish Ware mark stamped on bottom of "Standing Indian" pitcher.

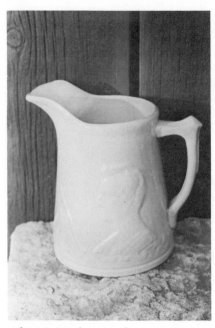

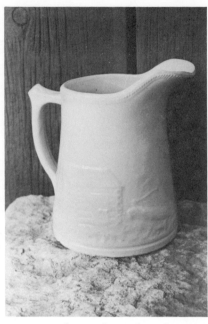

Abe Lincoln pitcher, Western Stoneware Co. Monmouth, Illinois. $200.00-225.00

Reverse of Lincoln pitcher showing log cabin.

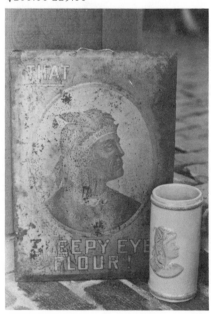

Tin Sleepy Eye Advertising Sign, 19"x13". As pictured, $300.00-350.00. In mint condition, $1,350.00-1,450.00

Cardboard advertising fan for Sleepy Eye Flour. $150.00-175.00

Stenciled Decorations

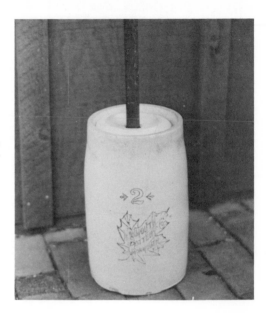

Two gallon butter churn, Monmouth Pottery, Monmouth, Illinois, c. 1900. $110.00-120.00

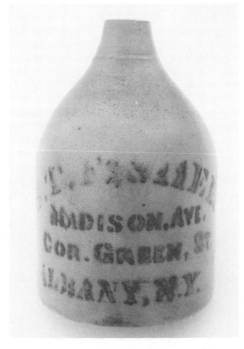

Vendor's jug from Albany, N.Y., no maker's mark, c. 1880's-1890's. Reverse of jug reads "This jug not for sale". $65.00-75.00

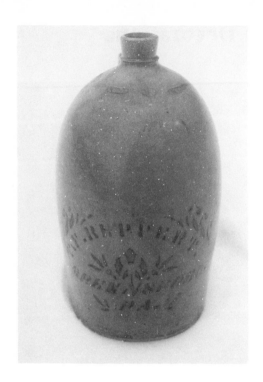

One gallon jug. Greensboro, Pa., c. 1880's. $110.00-120.00

One gallon vendor's jug. "John Coyne, Utica, N.Y." Made by N.A. White and Son, Utica, N.Y., 1882-1886. $110.00-120.00

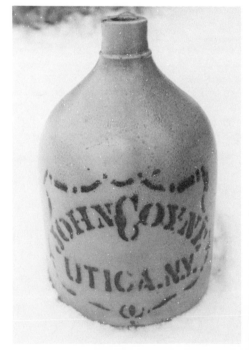

Golden Eagle Whiskey jug, two gallon. Made by N.A. White and Son. $95.00-120.00

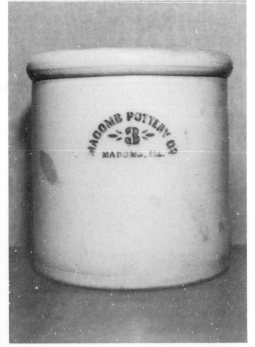

Macomb Potery Co., Macomb, Illinois, three gallon crock, c. 1900. $55.00-75.00

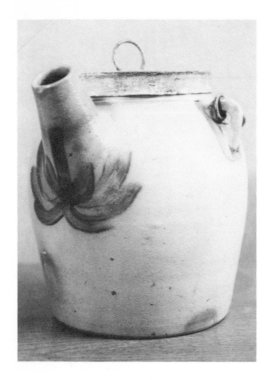

F.H. Cowden, Harrisburg, Pa., pancake batter jug, 1881-1888. Brush decoration around the pouring spout. $300.00-350.00

Stenciled decoration and potter's impressed mark on back of Cowden batter jug. It is unusual to find a batter jug with a combination of brush painting and stenciled decoration. The maker's mark on the back side of the batter jug is also interesting.

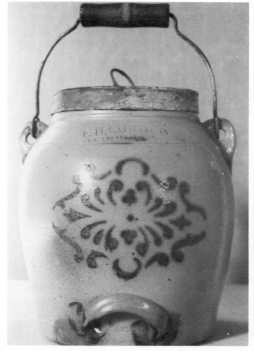

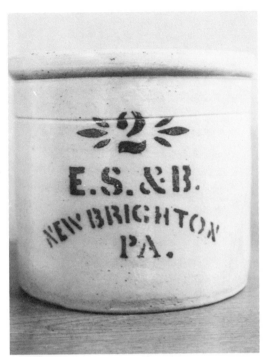

Elverson and Sherwood two gallon lard crock. New Brighton. Pa.. mid-1870's. $75.00-85.00

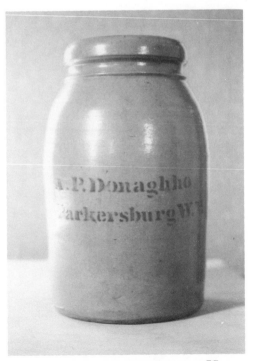

A.P. Donaghho. Parkersburg. W. Virginia. one gallon preserve jar. c. 1880's. $75.00-85.00

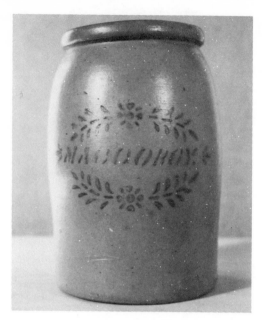

"Maccoboy" snuff jar, un-marked. Probably Penn-sylvania or West Virginia, c. 1880's. $75.00-85.00

Hamilton and Jones, Greensboro, Pa., five gallon jar. Stenciled and brush decoration, c. 1880's. $140.00-150.00

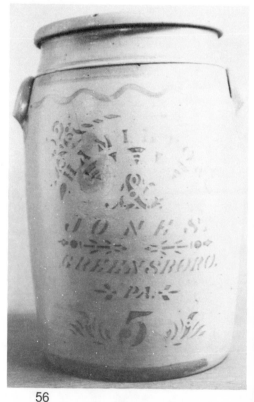

Sticenciled Whiskey Jugs

There is almost a countless variety of spirit and whiskey jugs still available to stoneware collectors. The majority have hand thrown tops joined with molded bottoms and a stenciled label that indicates the distiller or local seller of whiskey. Jugs that date from this period (1890-1919) seldom carry a potter's mark. At this point whiskey jugs are probably a good buy and an excellent long term investment.

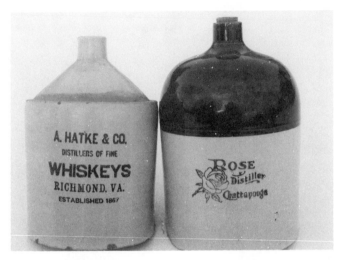

Hatke and Co., 3 gallon whiskey jug, late 19th century. Rose distiller jug, late 19th century. $55.00-65.00 each.

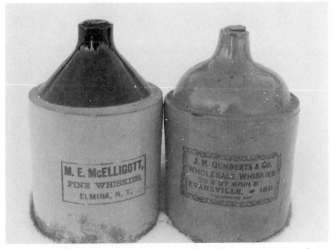

One gallon whiskey jugs, McElligott and Gumberts and Co., c. 1880-1900. $55.00-65.00 each.

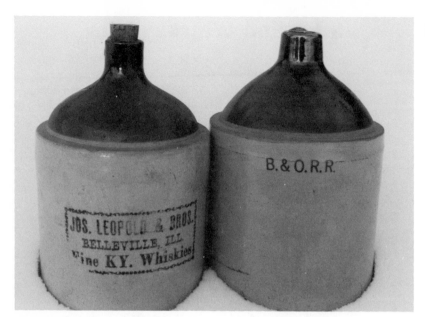

Jos. Leopold and Brothers one gallon jug. Baltimore and Ohio Railroad one gallon jug. $45.00-55.00 each. The upper sections of both these late nineteenth-early twentieth century jugs were hand thrown on a potter's wheel. The bottom sections were molded.

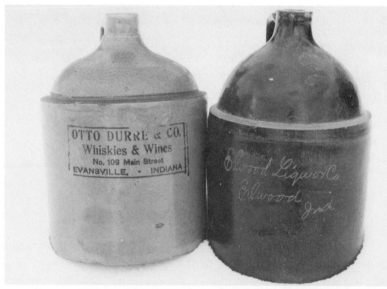

One gallon Indiana whiskey jugs, c. 1880-1900. $60.00-65.00 each. The Elwood Liquor Co. jug has the vendor's name incised into the Albany slip. Incised jugs with the vendor's name and location from 1880-1910 period are uncommon but not rare.

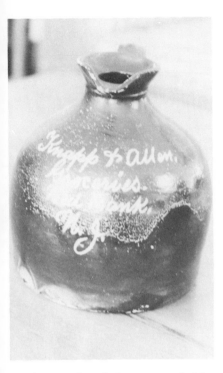 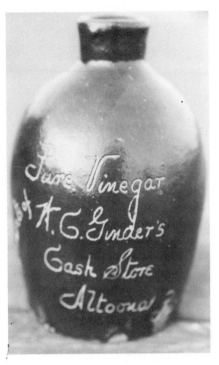

Pitcher-jug, hand thrown, probably a premium, incised "Knapp and Allen, Groceries, Red Bank, N.J." $75.00-95.00

Stoneware jug, unmarked, probably a premium or Christmas gift from W.G. Ginder's Cash Store, Altoona, Pa.. $100.00-110.00

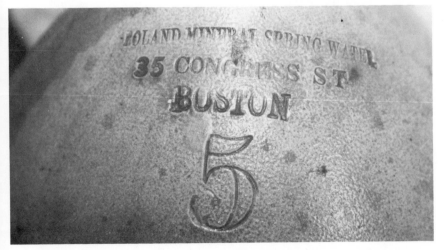

Impressed vendor's mark in five gallon mineral water pitcher-jug.

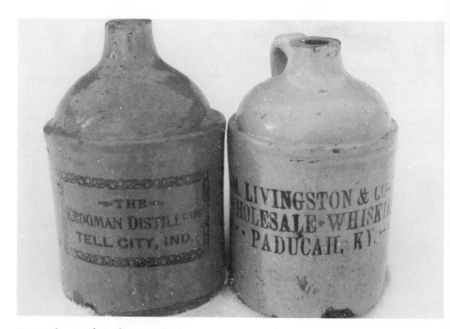

Kentucky and Indiana whiskey jugs, no maker's marks, ½ gallon size, c. 1880-1910. $45.00-50.00 each.

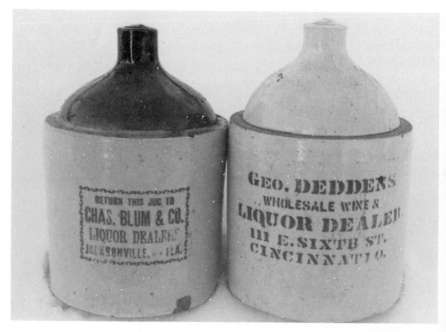

Illinois and Ohio whiskey jugs, no maker's marks, one gallon size, c. 1880-1910. $50.00-55.00 each.

Kentucky whiskey jug, one gallon size, no maker's mark, c. 1900-1915. $60.00-70.00

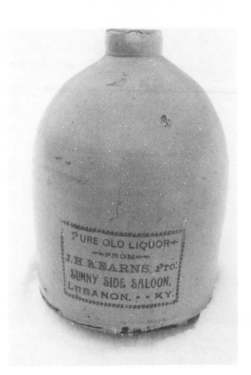

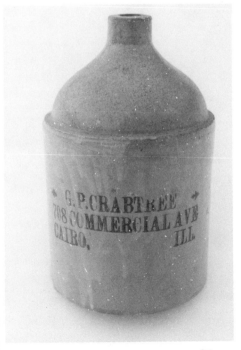

Illinois vendor's jug, c. 1880-1910, one gallon size, no maker's mark. $45.00-55.00

Specialty Pieces

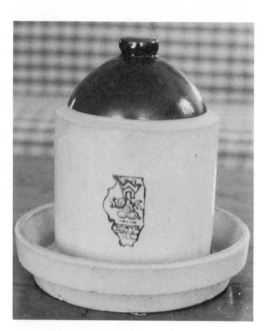

Poultry fountain, White Hall Pottery, White Hall, Illinois, first half of the 20th century. $50.00-55.00

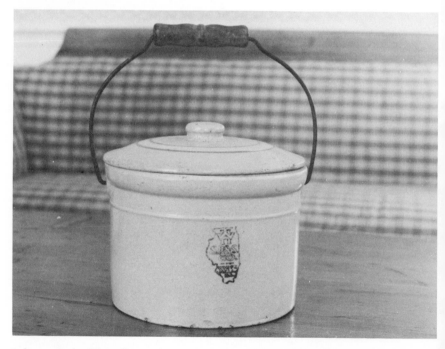

Salt crock, bail handle with maple grip. White Hall Pottery, first half of the 20th century. $50.00-55.00

Ice Water crock. White Hall Pottery. c. 1950. $70.00-75.00

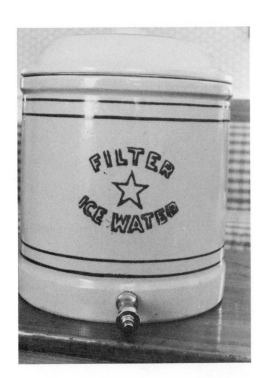

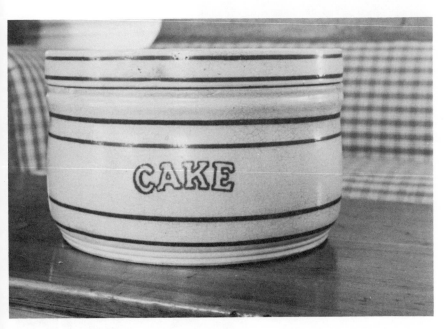

Cake Crock, White Hall Pottery. c. 1930. $115.00-130.00

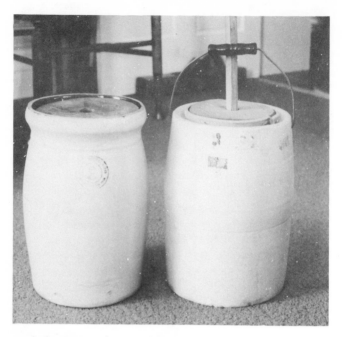

Ruckel's Pottery butter churns, c. 1900-1920. $65.00-75.00;
$95.00-100.00

School or lodge hall flag
holder, White Hall Pottery,
c. 1910-1920. $115.00-135.00

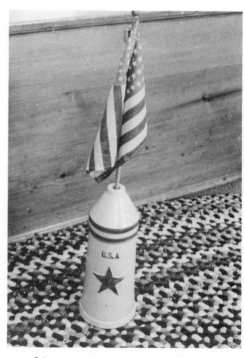

One gallon batter jug, original tin spout and mouth cover. Albany slip glaze, wire bail handle, W. Troy, N.Y., c. mid 1870's. $95.00-115.00. Batter jugs are found in sizes ranging from approximately ½ gallon to two gallons and were used to pour pancake batter. Batter jugs with decoration or a maker's mark are rarely found.

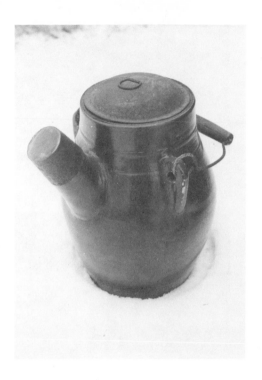

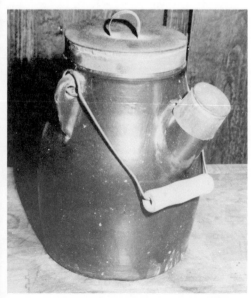

Unmarked batter jug, Albany slip, original tin spout and mouth cover, wire bail handle with wooden grip, c. 1870's-1880's. $95.00-115.00

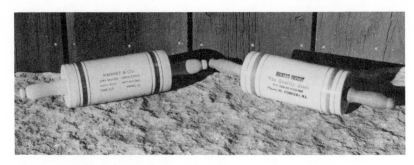

Stoneware rolling pins, maple handles. Given as premiums by grocery stores in Normal and Forrest, Illinois. Made by Western Stoneware Company, Monmouth, Illinois. $65.00-75.00 each.

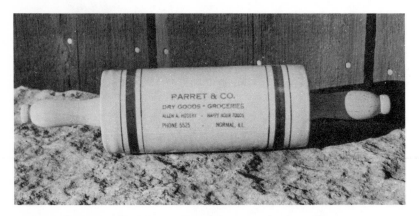

Close-up of Western Stoneware Company rolling pin.

Rolling pin, White Hall Pottery, White Hall, Illinois. $65.00-75.00

Green and Clark, 12 sided molded beer bottle. Brushed decoration at the neck, 1850-1860. $50.00-60.00
L.F. Milentz and Brother, 12 sided molded bottle, c. 1850-1860. $50.00-55.00

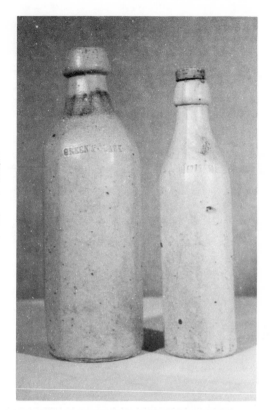

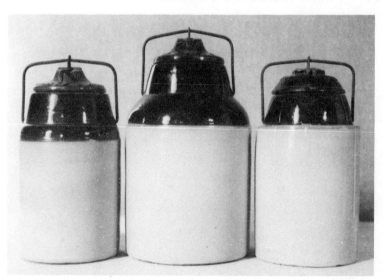

Weir Pottery, Monmouth, Illinois, molded preserve jars, c. 1890-1900. $35.00-50.00 each.

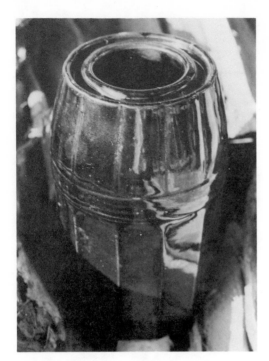

Peoria Pottery molded
preserve jar. Albany slip.
1890-1902. $35.00-45.00

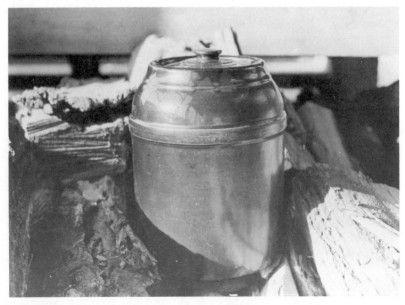

Peoria Pottery molded jar with lid. Albany slip glaze. c., 1890-1903.
$75.00-85.00

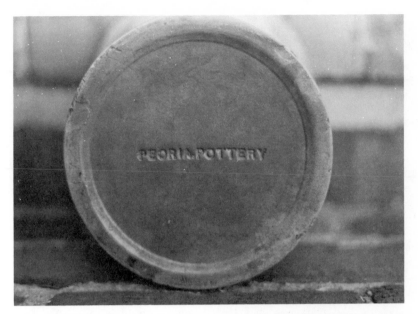

Impressed mark of the Peoria (Ill.) Pottery that closed in the early 1900's. Danial Greatback, Decius Clark, and Christopher W. Fenton came to Peoria from Bennington in 1859 to organize a western pottery.

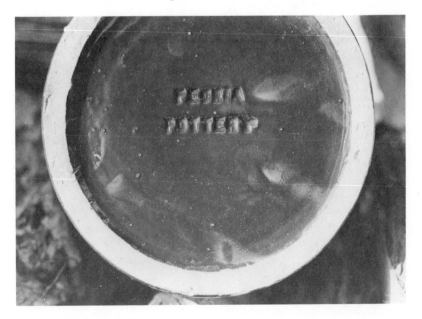

Another example of the impressed Peoria mark.

Peoria Pottery two gallon crock, impressed mark, molded, Albany slip. $65.00-75.00

Peoria Pottery two gallon butter churn, impressed mark. $200.00-250.00

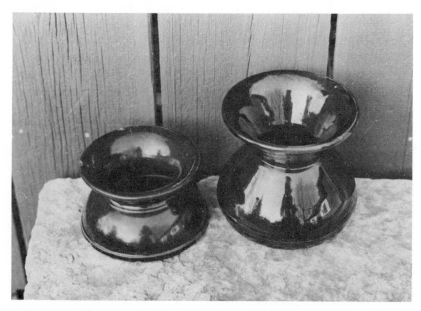

Molded Peoria Pottery spittoons. $100.00-125.00 each.

Morton (Ill.) Pottery Works crock, Albany slip, molded, c. 1900. $45.00-55.00

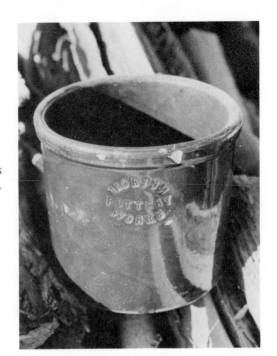

Morton Pottery Works impressed mark.

Ripley (Ill.) Pottery jar, 1880's. $45.00-55.00. The flecks of clay on this jar have been in place since a neighboring piece exploded in the kiln.

Rapp Brothers Pottery, Morton, Ill., molded stoneware clock case, c. 1900-1915. $50.00-60.00 each.

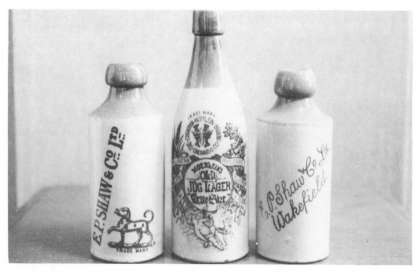

E.P. Shaw stoneware bottle, English, c. 1890. Moerlein's Old Jug Lager Beer bottle, Glascow Pottery, Trenton, N.J. c. 1880. E.P. Shaw stoneware bottle, English, c. 1890. $25.00-40.00 each.

Molded Stoneware

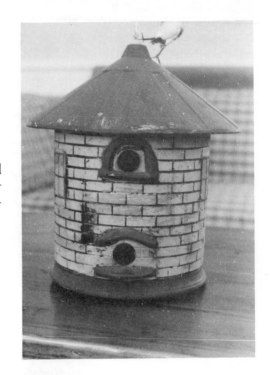

Molded stoneware bird house, c. 1910, White Hall Pottery, White Hall, Illinois. $150.00-175.00

Sponge decorated molded jar with lid, Red Wing Pottery, Red Wing, Minn., c. 1910. $50.00-55.00

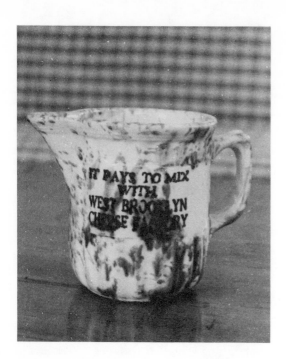

Molded pitcher, "It pays to mix with West Brooklyn Cheese Factory," c. 1930, no maker's mark. $20.00-25.00

Spatter ware pitcher, first half of the twentieth century, no maker's mark. $30.00-35.00

Pitcher, Rockingham glaze, first half of the twentieth century, no maker's mark. $20.00-25.00

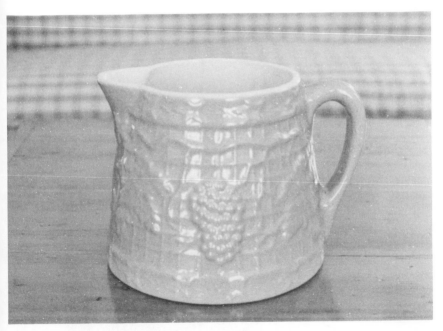

Molded pitcher, grapevine decoration, White Hall Pottery, c. 1900-1915. $50.00-65.00

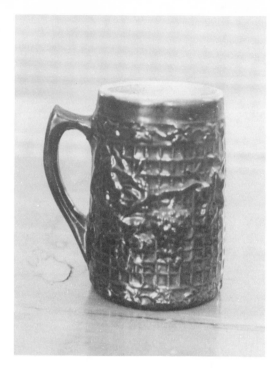

Molded mug, grapevine pattern, White Hall Pottery, c. 1900-1915. $40.00-45.00

Pitcher, molded stoneware, c. 1900. $55.00-65.00

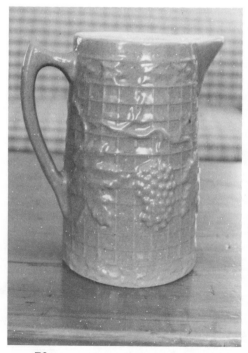

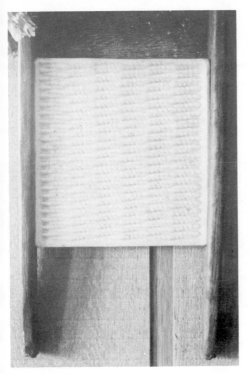

Molded stoneware jar, Albany slip, c. 1900, no maker's mark. $25.00-30.00

Washboard, molded stoneware, pine frame, no maker's mark, c. 1880-1900. $55.00-75.00

Molded stoneware funnel, White Hall Pottery, c. 1900. $20.00-25.00

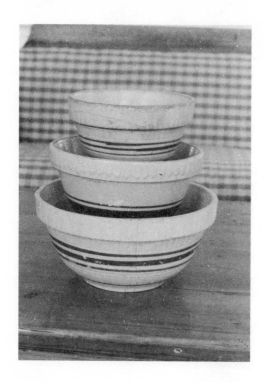

Stack of molded mixing bowls, c. 1920, probably White Hall Pottery. $12.00-15.00 each.

Molded salt crock, White Hall Pottery, c. 1890-1910. $55.00-60.00

Molded pitcher, c. 1900, no maker's mark. $60.00-65.00

Molded jar, sawtooth pattern, White Hall Pottery, c. 1900. $30.00-35.00

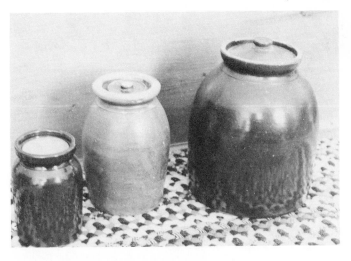

Stoneware jars, c. 1910, Ebey Pottery, Winchester, Illinois. $12.00-15.00; $20.00-25.00; $35.00-45.00

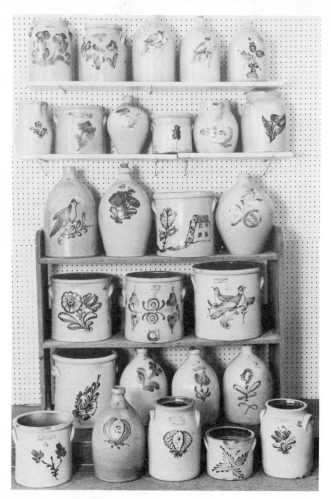

These twenty-seven pieces of cobalt decorated stoneware are from the collection of Muleskinner Antiques, Clarence, New York. On the top row is a rare 1½ gallon jug with a pot and three large flowers from the W. Roberts Pottery of Binghamtom, N.Y. The second row contains a decorated ovoid jug (c. 1830's) and a decorated batter jug.

The crock with the slip trailed school house and tree (Braun Pottery, Buffalo, N.Y.) is a rare and unique piece of decorated stoneware. It is 11½" tall and has a diameter of 12".

The crock with the double birds is also uncommon. It is marked "Doubleday and Elders, Cooperstown, New York". It is interesting to ponder if the Doubleday of Cooperstown was the Abner Doubleday who is given credit in some quarters for the invention of baseball.

The pieces in this collection were all hand thrown and either brush painted or slip trailed with cobalt. They date from the 1830's to the 1870's.